Images from the Neocerebellum

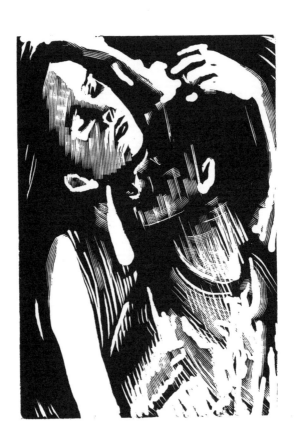

Images from the
Neocerebellum

The Wood Engravings of
George A. Walker

The Porcupine's Quill

Library and Archives Canada Cataloguing in Publication

Walker, George A. (George Alexander), 1960 –
 Images from the neocerebellum / George A. Walker.

ISBN 978-0-88984-291-5

 1. Walker, George A. (George Alexander), 1960 – .
I. Title.

NE III3.5.W35A4 2007 769.92 C2007-901262-0

Published by The Porcupine's Quill, 68 Main St, Erin, Ontario N0B 1T0.
http://www.sentex.net/˜pql

Readied for the press by Tim Inkster and Doris Cowan.

Represented in Canada by the Literary Press Group.
Trade orders are available from University of Toronto Press.

We acknowledge the support of the Ontario Arts Council and the Canada
Council for the Arts for our publishing program. The financial support of
the Government of Canada through the Book Publishing Industry
Development Program is also gratefully acknowledged. Thanks, also, to the
Government of Ontario through the Ontario Media Development
Corporation's Ontario Book Initiative.

 Canada Council
for the Arts

Conseil des Arts
du Canada

 ONTARIO ARTS COUNCIL
CONSEIL DES ARTS DE L'ONTARIO

And since all the same thoughts and conceptions which we have while awake may also come to us in sleep, without any of them being at that time true, I resolve to assume that everything that ever entered into my mind was no more true than the illusions of my dreams. But immediately afterwards I noticed that whilst I thus wished to think all things false, it was absolutely essential that the 'I' who thought this should be somewhat, and remarking that this truth 'I think therefore I am' was so certain and so assured that all the most extravagant suppositions brought forward by the sceptics were incapable of shaking it, I came to the conclusion that I could receive it without scruple as the first principle of the Philosophy for which I was seeking.

— René Descartes, *Discourse on Method* (1637)

Dreams Are the Bones of the Psyche
AN INTRODUCTION

Dreams are the visions that define us, the sum total of our varied personal life experiences. To ignore the vivid distillate of our subconscious is to practise a form of wilful blindness that will easily prevent us from understanding ourselves at all clearly. The images I have selected for this book are wood engravings inspired by my own dreams. The engravings are part of a much larger collection of dream images I have compiled over the years from the dream diaries I first encountered in Dr John M. MacGregor's 'Inscape Psychology' courses at the Ontario College of Art in the 1980s. An essential part of the course requirement insisted each student keep a daily dream diary. The methodology was simple enough: set an alarm clock in the evening primed to startle you to sudden wakefulness in the morning, then commit to paper immediately whatever fragments could be salvaged from the night past, before the fanciful thoughts dissipated in the bright glare of dawn. I became obsessed with the practice and continue to record my dreams daily, twenty-five years further on ... often using the nineteenth-century medium of wood engraving, pushing sharpened burins into the planed surface of endgrain Canadian maple.

The notion of creating artwork to explore and interpret the unconscious dream state is hardly a novel idea. The psychiatrist Carl Jung explored his own unconscious by painting pictures of his dreams that he recorded in a journal entitled *Red Book*. Jung believed that the creative imagination materialized through drawing and painting and served as an excellent medium to record his dream discoveries. 'The "manifest" dream picture is the dream itself and contains the whole meaning of the dream,' wrote Jung in *The Practical Use of Dream-Analysis*. William Blake, a visionary artist, noted the connection between his dreams and his art and believed that he learned how to paint from a series of dreams. The Tate Gallery in London has a pencil sketch by Blake titled 'The Man Who Taught Blake Painting in His Dreams'. The image in the Tate is actually a counterproof (a reversed image made by rubbing a clean

sheet of paper over the original). It is a mirror reflection of Blake's dream (pun intended). Salvador Dalí's fascination with dreams was inspired by Sigmund Freud's seminal book *The Interpretation of Dreams*. Dalí deliberately set about trying to create dream photographs, a literal picture of the subconscious. André Breton, in his book *Manifestoes of Surrealism*, suggests that surrealism is an attempt to blend these two contradictory states of being — the dream and reality — into a new, absolute reality called surreality. If dreams indeed are to be understood as a direct link to our unconscious, perhaps it is to be expected that artists will be inclined to analyze and exploit the rich landscapes of the mysterious world of their own dreams.

Jung has said 'My situation is mirrored in my dreams,' and this statement summarizes exactly what this book attempts to be — an exploration of my subconscious through my art; my situation through my dreams. When I wake from a dream I first try to order the events and then to collate them into a single image that might represent the characteristics, mood or feeling of the event. These images reflect my search for meaning found through dreams and their symbols in the form of archetypes arising from both the collective unconscious and my own conscious experiences. Since I started to document my dreams I find I often experience a type of lucid dream in which I am uncertain at first if I am awake or asleep. When I am convinced I am dreaming I begin to explore my unconscious world, unwrapping old recurring dreams and working to resolve conflicts between characters representing my foils and foes. I believe that the greatest form of self-discovery is enabled through dreams. Freud remarked that the desires which shape our dreams are not the sort of desires one openly acknowledges, but rather are wants that are repressed, either because of some painful nature or because they are habitually excluded from conscious reflection while we are awake.

Why do I bother with the extraordinary effort required to engrave my images onto the endgrain of maple? For me wood is a natural choice for exploring my inner dream world because the technique is so process-oriented that I am provided ample time to reflect on the frozen moment in dream-time I am attempting to capture. Then

there is also the metaphoric relationship between the qualities of trees and the dream state and the conscious world. Trees have two distinctly different features: the beautiful foliage and branches that appear above ground, and the tangled searching roots that are hidden underground. The tree, therefore, can be seen as a metaphor for our own experience in the world — the conscious world above ground and the unconscious dream root hidden beneath the soil that is so essential to the prosperity of what flourishes above.

The neocerebellum is the part of the brain that controls fine motor movements such as those required to create the fine white lines I incise into wood with my engraving tools. I engrave my images on the endgrain of planed maple wood blocks. This process is known as wood engraving, as distinct from wood cut, in that the images are carved into the endgrain of the block instead of along the plank. Engraving on the endgrain allows for much finer detail without risking the negative effects of the wood splintering as it is being cut. When the images are printed they appear reversed from what was drawn onto the block. This reminds me of the dream imagery found in *Through the Looking-Glass and What Alice Found There* by Lewis Carroll. Alice falls through a mirror into a world of dreams and enchantment. I relish the parallels that I find between my brain's inner process and the practice of creating original wood engravings. Consider, for example, the way the brain reverses imagery through the lens of our eyes, or, similarly, the way in which our dreams are reflections of our unconscious.

The metaphor of the dream and the tree is not a new concept. Other cultures have also used wood as a portal to the dream world. The Cuna, for example, who live on the San Blas Islands off the Atlantic coast of Panama use wooden objects to help eliminate bad dreams. The Cuna believe there are eight levels of reality beneath the surface of the land they inhabit, and that one can descend through the layers (kalus) beneath the ground to discover the meaning of certain dreams. It is interesting to compare the Cuna's understanding of the steps to the unconscious with our own limited knowledge in which we continue to grapple with such questions as whether meditation is

9

the same as daydreaming and whether a hypnotic trance is the same as sleepwalking. It was this search for the unconscious world within the mind that led to experiments with mind-altering drugs that defined a generation in the 1960s and 1970s. This was a feeble attempt by Western pop culture to appropriate the hallucinogens of indigenous peoples to discover a new reality and perhaps a clearer understanding of the eternal question ... what is God? Wade Davis in his book *One River* describes how the people of a South American tribe can speak to God directly when the need arises. They must first ask the shaman to guide them on the journey. The shaman provides a drug concoction that is very potent and causes the subject to become violently ill before being overcome with visions and an epiphany. The question is, are these more correctly to be characterized as dreams or hallucinations, and is there a difference?

The Iroquois believed that dreams contained encrypted messages from one's soul that must be resolved. The meaning of a dream was carefully analyzed. Each member of the community would be asked for an interpretation or acting out of the dream so that members could comment. The dream-sharing ritual of the Iroquois was a part of their mid-winter dream festival and underscored the importance of dreams to their cultural health. To ignore a dream for an Iroquois was to court bad luck and misfortune.

It is my personal belief that 'dreams are the bones of the psyche' because it is within dreams that all our understanding of self begins and ends. My own dream diary is a record of the most surreal and visually absurd sequential inner narratives distilled into single images. Although the mystery of lucid dream imagery and the more pedestrian waking life may seem not to be related it is the dreamer himself that is the conscious story in front of the dreaming mind that ties these two aspects of being into a single concept of self. The dream skeleton underpins our waking life.

— *George A. Walker*

The Engravings

Tree Eater — January 2007

I feel an odd sort of a sensation in my chest.
I try to open my mouth to say something,
then the trunk of a tree emerges from my throat.
For a moment I can't breathe.

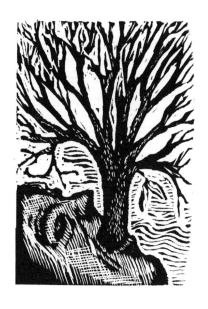

Secretary — January 2007

I am waiting in a room full of people, sitting in
chairs, everyone staring blankly at the walls.
I approach a receptionist who is typing frenetically.
Then I notice that the woman's computer monitor
is hard-wired directly into her forehead.

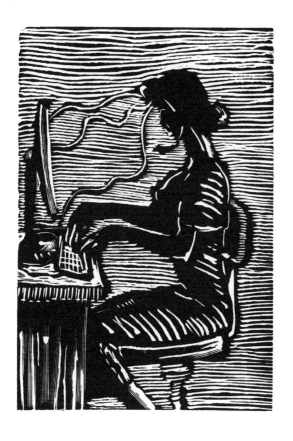

Meeting My Subconscious — January 2007

I wake up, and sit for a moment on the edge of my
mattress. I am annoyed that I can remember
nothing of the night just past to record in my dream
diary. The walls begin to move as I puzzle over this
unexpected bit of memory loss, then a little girl
darts suddenly out from a corner and places a hand
gently over mine. I try to force myself to look
directly into her eyes, but as I lean forward her face
pulls back again into the shadows. A sense of
anxiety permeates my body as I realize I must
still be dreaming.

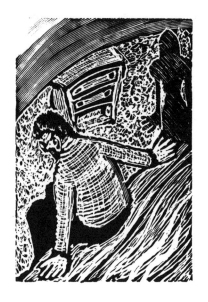

Four Maidens — January 2007

Four women appear in front of me ranging in age
from maiden to crone. They gesture with their
fingers as they look first inquiringly in my direction
and then back to the business of their hands.
I am unable to make much in the way of sense from
their pantomime. I try to speak but no sound
passes my lips.

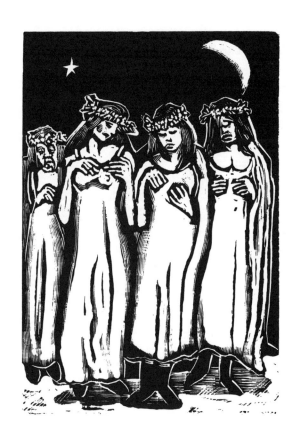

Mask Painting — January 2007

I arrive at the entrance to an exhibition of paintings mounted in a large art gallery. I've apparently been invited to speak in public at the vernissage, and to introduce the artist. The curator shows me to a room hung with the featured artist's work and I realize that I'm familiar with none of it. One of the paintings, in particular, catches my attention. The work depicts a male head with an opened mouth and a printed note stuffed into the cavity. Several people in the gallery pass by the note and laugh, but I can't seem to comprehend the humour inherent in the text myself.

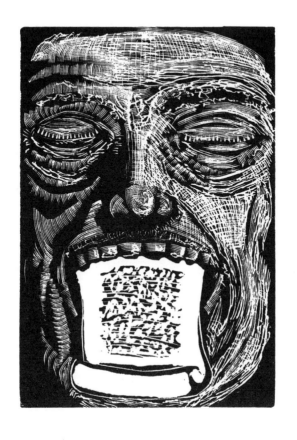

Ouroboros — January 2007

I watched a completely idiotic movie once called *Snakes on a Plane*, and sure enough the following night I conjured up the classic Ouroboros image of a snake consuming itself in a dream. Perhaps the subliminal message intended was that my long hours of daily toil may be consuming more than just my time? Perhaps in future I should learn to choose sleep in preference to Hollywood blockbusters.

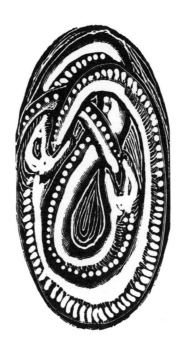

Spinning Thoughts — January 2007

Several times, just before morning,
I've experienced similar sorts of typhoon visions
that feel as if the Milky Way is spinning and
sparkling out from my skull.

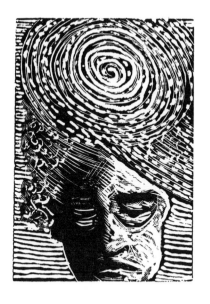

Big Hands — January 2007

Many people encounter recurrent dreams in their
childhood that become less frequent as they age. I
have one such dream in which my hands bloat to an
enormous size and then shrink. Then my feet swell,
and also shrink. When I was younger the dream
was alarming. Now it has become familiar and
predictable and even a bit tedious. My typical
reaction now is often to think 'not this again' when
the big-hands dream makes another of its
infrequent appearances. Jung claims, in his essay
'On the Nature of Dreams' (1947), that recurrent
dreams are caused by what he calls 'psychic
situations' and that one method of uncovering their
cause may be to analyze the records in a dream
book. I do this myself, but the only 'psychic
situation' I can identify in this case is that the big-
hands dream is often associated with health issues
such as the onset of influenza, a head cold or injury.

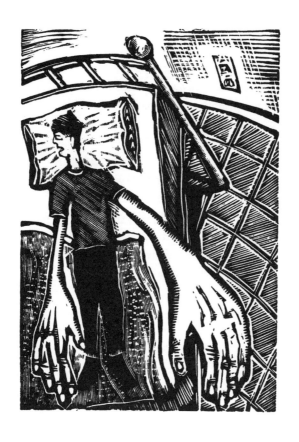

Bus Accident — January 2007

I am holding a baby in my arms, and I find myself
standing in the middle of a busy urban street
crowded with buses. For some reason that is
unclear one of the buses runs both of us down.
I clutch at the baby tightly as I watch the
undercarriage of the bus pass slowly over my head
(the whole dream proceeds in stop-frame slow
motion). The baby and I are not injured by this
first strike but then a second bus also begins to run
over us and this time a bit of protruding metal
under the bus catches my shirt. I yell for help.
A crowd appears around the wheel well of the bus.
I reach out to hand the baby to a stranger as the bus
continues to pass over my chest and legs.

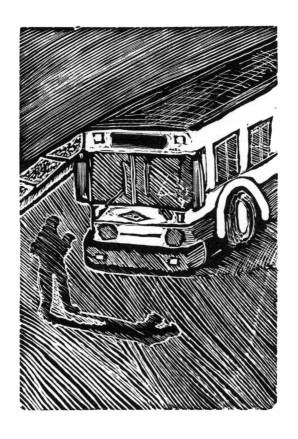

Hand Smoke — December 2006

I see a man wearing a mask standing in front of me.
At first I think the man may be smoking a cigarette
but then I notice that his hand is holding nothing.
The man waves his fingers in the air and the smoke
billows into swirling clouds. Just beyond his head a
cloud of smoke coalesces into a face and begins to
speak, though I can't begin to understand what the
face might be trying to say.

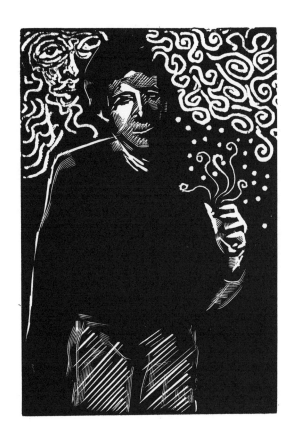

Aife — December 2006

On rare occasions I've experienced erotic
encounters with strange women in my dreams.
This particular lady of the night was smoking in the
nude and asked if I'd like to see what she was
thinking. To which I responded, 'How would I go
about doing such a thing?' To which she replied,
'Like this', and pulled at one of her ears to open
some sort of energy portal into her skull, which
flooded the room with her thoughts and knocked
me quickly back into consciousness.

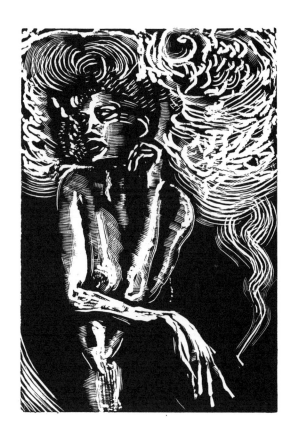

I fall into a deep sleep. I feel myself spinning.
Occasionally I bump into others as I descend into
this spiral portal to my unconscious. I brush against
one winged character, in particular, who scowls at
me as I fall past him. I want to excuse myself, but I
am too startled to think quickly enough of the right
thing to say to excuse my clumsiness.

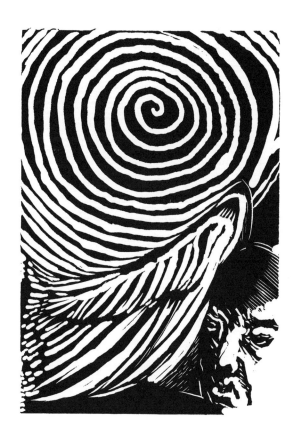

Hall of Doors — December 2006

In this recurrent dream I wander through the
corridors of a school. I can't find my locker and I'm
late for class. When I do, finally, come upon a
classroom with an open door, I cannot make sense
of the books or comprehend the lesson the
instructor is teaching. I feel a sense of inadequacy.
I excuse myself and leave the class. As I continue to
explore the halls I find I'm unable to locate anything
that looks familiar though I am determined to fix
on a landmark to orient myself. I often encounter
this dream when I'm trying to memorize something
or to learn new concepts.

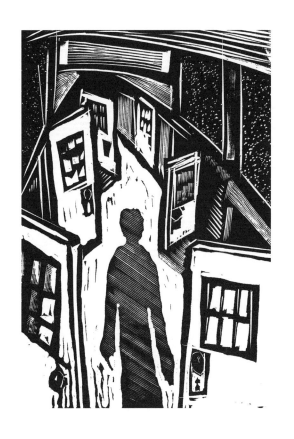

Lovers — December 2006

Sexual encounters in our dreams are one
manifestation of our deepest feelings about our own
sexuality and the ways in which we express
ourselves as sexual beings. When asleep we convert
our conscious reality into fantasies that explore the
nature of who we are, as individuals, and how we
communicate with our lovers. My own erotic
dreams are often very sensual.

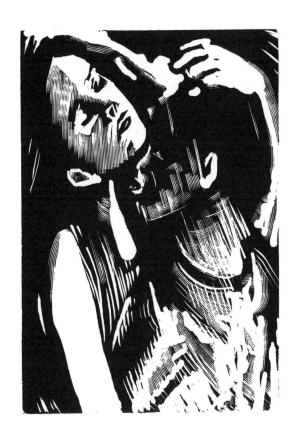

Writing, drawing — December 2006

Damn — I could have sworn I was awake! Here I am writing and drawing images, making steady progress on some work that needs to be finished quickly when I realize that I'm not even awake.

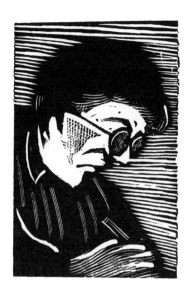

Doves — December 2006

I'm outside, walking on a sidewalk at night. I hear a
flock of doves flapping their wings above my head.
I look up and half a dozen birds are swirling above
me, each one trying to steal a twig from the next.

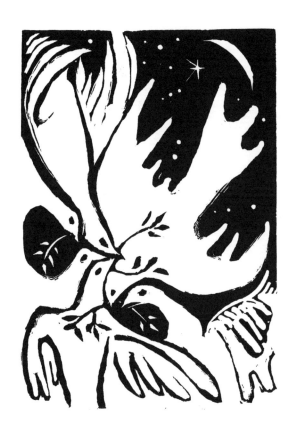

The Adversary — December 2006

The feeling of dread arrives from nowhere. What is
clear is that I'm suddenly threatened and that I
must defend myself. A figure emerges from the
darkness and intimidates me with angry words.
I strike out at it with my fists but the figure is made
of papier mâché and falls away.

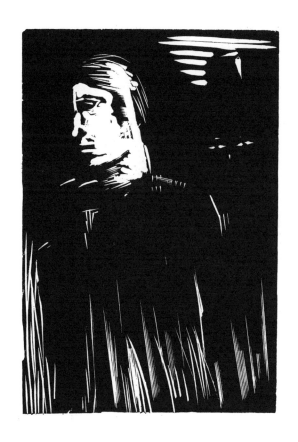

Night Cats — November 2006

Two cats play with each other on a chair in a
darkened room. There is a window through which
I can see a crescent moon and a single star, probably
actually a planet. Venus, maybe. The cats are
engaged in a game that requires the one cat to climb
onto the chair, and then to jump over the other cat.
Each cat lets out a meow as it jumps. The cats circle
each other, and the chair, repeatedly.

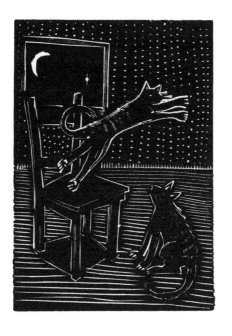

Street — November 2006

The street is dark except for a few street lamps.
With every step I take I hear my footsteps echo
along the pavement. Then an eerie silence settles
over the scene, smothering the sounds of the night.
I stamp a shoe on the asphalt but I hear nothing.
I'm unsure whether it's me that has gone suddenly
deaf, or if it's the world that has gone mute.

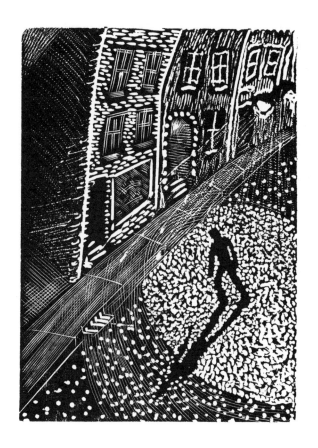

Steppenwolf — November 2006

I run through the woods, flailing and stumbling and tripping over deadfall as I go. One larger branch catches my shin and I hit the floor of the forest face first. My chest slams into the leaves on the ground and then I feel myself mutate from man into animal. A wolf pulls itself up out of my body and continues the chase deeper into the woods at full stride. The running is effortless now and I race past thickets of trees moving like the wind.

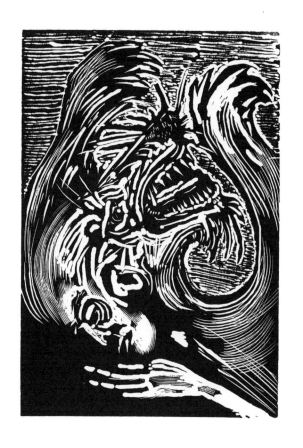

Night Jasmine — October 2006

A woman is seated at a table. She is nude.
The room is filled with the scent of white jasmine
blossoms. Whatever that fragrance might be.
The woman has a vacant look in her eyes as she sits
waiting for someone. After a time the woman looks
up, notices me, and smiles.

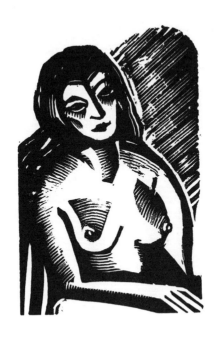

Figure with an Eye — October 2006

A male silhouette is doing jumping jacks,
vigorously, in a gymnasium. The calisthenics room
is shrouded in mist. At the centre of the swirling
mist a single eyeball stares straight ahead, blinking
at me. The eye is small. So small I wouldn't have
noticed it except that the gymnast is not clearly
defined but the one little eye is focused by
comparison, and the mist seems to circle around it.

Woman in Conversation — October 2006

I find myself in conversation with a dark-haired
woman who humours me with an amusing story.
The woman insists that I follow her. I'm reluctant
to do that because I'm convinced that I have never
met her before. I ask her to identify herself.
She vanishes.

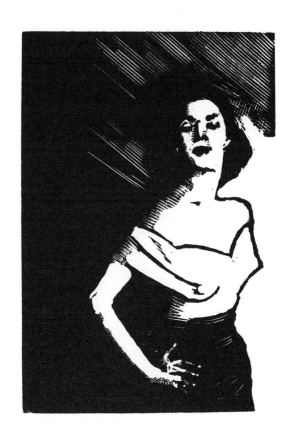

My Chair — September 2006

I am led to a dark place in which a chair and a single incandescent light bulb are the only objects visible. I am told to 'wait' by some authoritative voice that sounds as if it may be close at hand. I suspect I may be about to undergo some sort of interrogation. The light bulb dims further into blackness and the voice instructs me to sit.

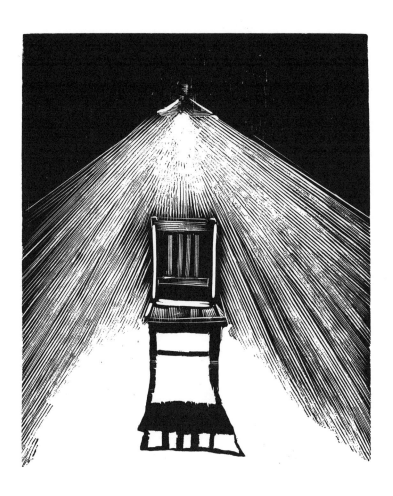

Through the Looking-Glass — September 2006

I see a mirror on a wall. The glass is wide, very
much more so than high. I position myself in front
of it. When I approach the mirror the only
reflection I can see is the top portion of my head.
No matter which way I turn my neck or how I
adjust my position in front of the mirror, I am able
to see only the same reflection of my forehead.

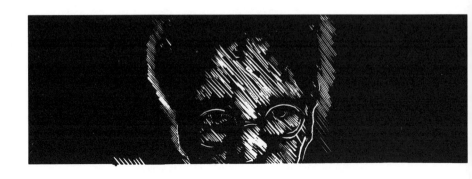

Cat Reflections — September 2006

It could be the sound of the cats scratching at our
bedroom door or it could also be the occasional
meow in the night that invites these little beasts
into my dreams. The cats often appear in strange
places morphing into other things and people.
This particular cat is looking at itself reflected in a
low hung mirror. The cat twists and turns its head
but the reflection in the mirror can't keep pace with
the changes in the cat's movements. The mirror
becomes a sort of a time delay for the cat's every
movement.

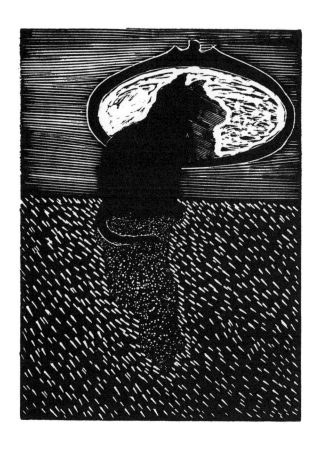

Cat's Meow — August 2006

A cat is circling the floor near one wall of a
bedroom. I find it difficult to believe but the cat
begins to speak, saying, 'I cannot confer, I cannot
blame, I am not here, I am a cat.'

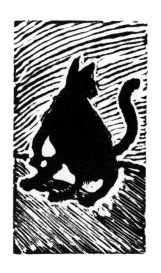

Hyper-Cerebral Electrosis — July 2006

Hyper-cerebral electrosis is a phantom medical condition that supposedly arises during intense mental activity when an excess of current surges through the brain. The brain explodes! I first learned about this contemporary urban folktale the night before I had this dream. Thoughts kept building inside my skull until — kaboom! I woke up. As the actor Rod Steiger has noted elsewhere 'One of the greatest sources of creativity is terror.'

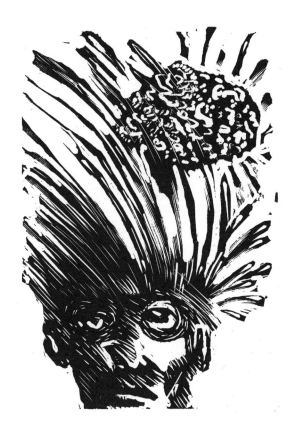

The Patient — December 2005

A man sits on the edge of a single bed in a small room. I think the room may be part of an asylum as the whole dreamscape has an institutional feel to it. The man on the edge of the bed stares blankly at a door, seemingly morphing from a young man to an old one and back again.

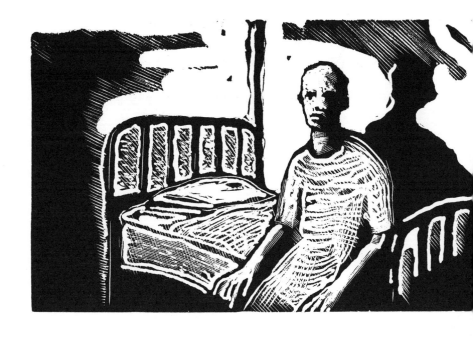

Evergreen Harvest — November 2005

At the edge of a frozen forest I drag a cut spruce
tree over the snow. It is night. In the sky I can see a
crescent moon and a single planet, likely Venus.
An Islamic cleric emerges from the forest and
motions to the sky and speaks but I don't
understand what he says. (Turn the page upside
down to see the cleric.) I used this image for my
Christmas card in 2005.

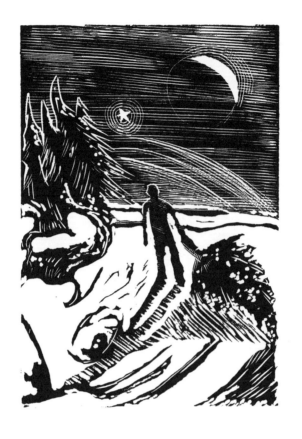

Should I draw or should I eat? — November 2005

The room is dark. I am sitting at a table. A man
walks in and places a pencil in one of my hands and
a spoon in the other. The man explains that I must
choose — to draw or to eat.

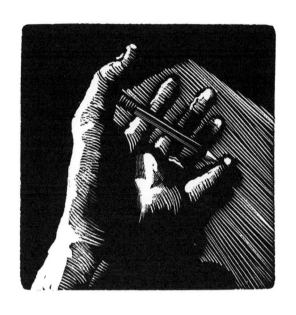

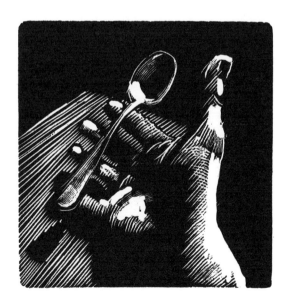

Sewing — October 2005

My fingers have fallen off at the knuckles. I begin to
carefully sew each finger back into its individual
socket. The difficulty is that I am sewing my hands
together with fingers that are in disarray. I struggle
to maintain control of the needle and thread.

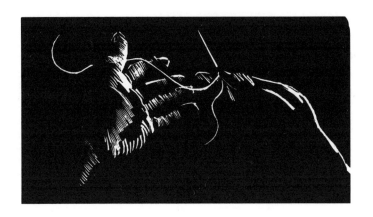

A Glass of Wine — October 2005

My wife Michelle and I sit in a small restaurant
drinking a glass of red wine. I get up from the table
to go looking for a washroom. When I return my
wineglass and chair have been removed and
Michelle is no longer sitting at the table.
In a fit of panic I ask the maître d' if he has seen my
wife when she suddenly reappears, asking me
calmly where have I been and why have I not
returned to the table. But there aren't any tables —
the room is empty.

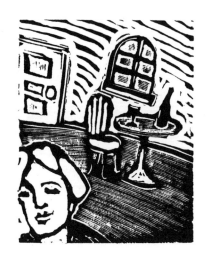

Algonquin Park — August 2005

A hot summer afternoon in Algonquin Park. I sit on a rocky outcrop overlooking a lake. The water is calm and looks invitingly cool. Suddenly the wind quickens. A man emerges from the surface of the lake. He is not visibly wet but he does quickly glance back once at the water before disappearing into the woods. The stone I'm sitting on is warm to the touch. I lie back and mould my spine to the shape of the rock. Then the landscape dissolves.

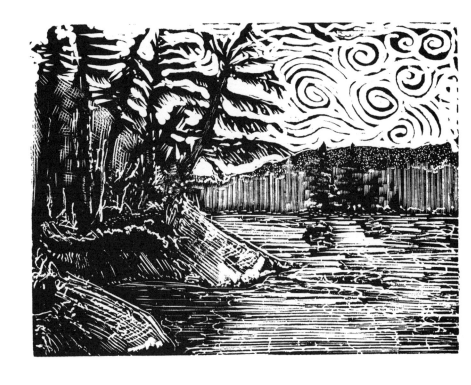

Closed Eyes — July 2005

I begin to feel myself about to break into a million particles. The process begins at my head and moves slowly down through my neck and shoulders. The sensation is not unlike pins and needles except that I can feel the sharp points pushing through my skin and out into the air.

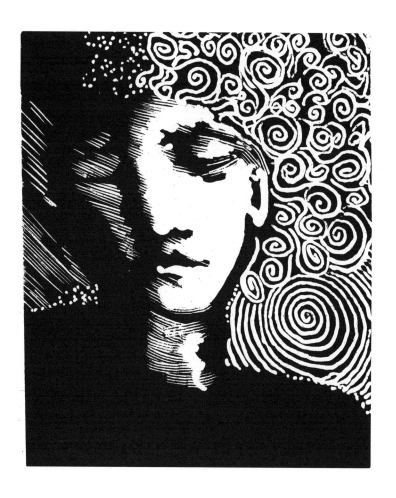

Brothers — June 2005

I am the proud father of two sons who are six years apart in age. I often find myself reconsidering some part of their actions or decisions before I fall asleep and so it is no surprise that visions of the boys follow me into my unconscious. Here my sons appear as silhouettes, but I can see straight on through inside of their heads where their thoughts appear animated in images.

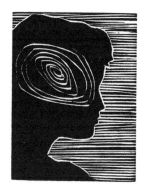

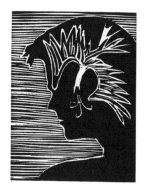

Boat — June 2005

It's night. I'm sailing on a boat in rough water.
I look out one of the portholes. I can see fish
jumping into the air and water spraying high over
the bow. There is no one else on the boat and I'm
no sailor. My mind races, trying to remember how
it was that I managed to get myself into this
predicament — but I'm unable to remember
anything of the chronology.

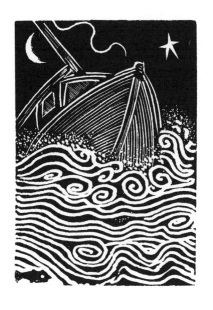

Hero the Cat — May 2005

Hero the cat is playing on top of a bed.
Odd, because I don't usually allow cats on the bed.
Doubly odd, because Hero is playing with the
head of another cat. The 'cat head' is alive and
meowls in protest while Hero continues quite
happily to bat the head around the mattress. I ask
my wife if she knows how the 'cat head' came to be
alive when it obviously doesn't have a body.
Michelle doesn't reply.

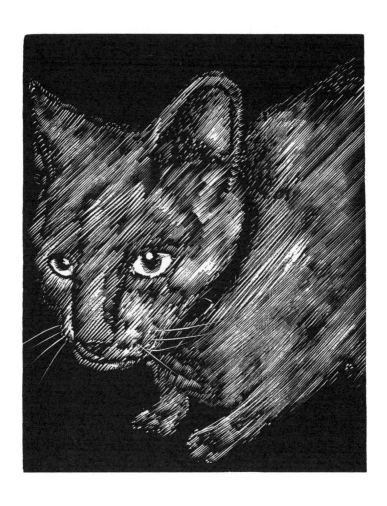

Prisoner — June 2004

I am chained and belted into a harness. I cannot move or speak. A black hood hangs over my head. I imagine this must be in preparation for my execution though I'm uncertain what crimes I have committed or who has decided to hold me in bondage. Later, I manage to escape when I notice my captors are no longer watching closely.

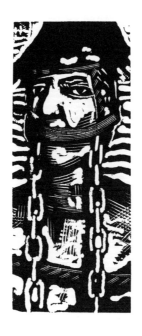

Sleeping — February 2004

I float above my bed looking down at myself
sleeping. The moment I fall back into myself,
I convulse into consciousness.

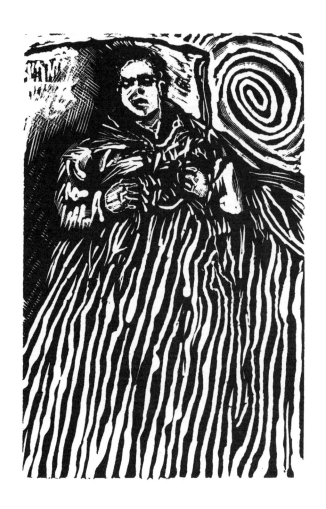

Lovers — January 2004

She runs her fingers gently through my hair.
I hold her in a tight embrace. She's so warm and
soft and … it's my pillow.

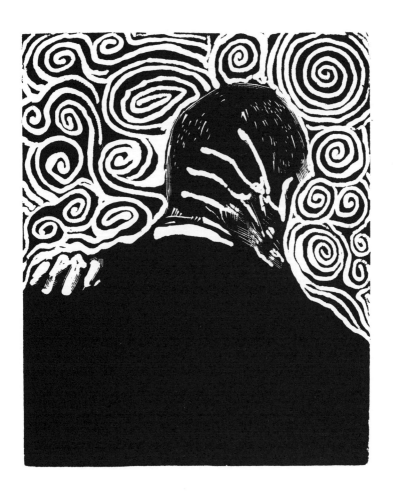

Doppelgänger — December 2003

A teacher lectures at a podium. I can understand
nothing of what is being said but I can certainly
appreciate that there is real passion in the delivery
of the message. Then I realize that the lecturer is
actually myself. I turn away, but that only agitates
my doppelgänger further. I break into a sprint,
putting distance between myself and the voice.

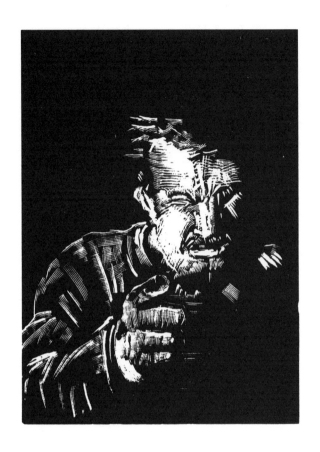

Fear — November 2003

When I was a boy I frequently experienced a dream
that seemed so real I would lose my breath and be
unable to speak. The dream was always the same.
A very large motionless shadow loomed over my
bed, close enough that I could hear it breathing
though it never spoke. I would try to yell at the
shadow but the words couldn't force their way
out of my lungs.

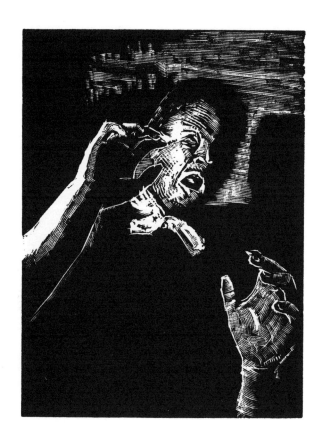

God of Wind — November 2003

While working on the illustrations for Jack
Ketchum's *The Transformed Mouse* I struggled to
visualize an image for the character known as the
God of the Wind until I found a solution in a
dream. I'm caught in a wind storm at the foot of a
hill I intend to climb. As I reach the middle of the
incline I look up to see a very large man blowing a
hurricane wind out of his mouth as he sucks his
belly like a bellows and the wind intensifies.
I fall back down the hill and he disappears.

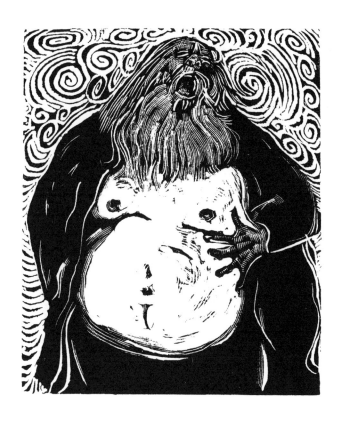

Nine-armed Matilda — October 2003

I'm standing in front of a woman who begins
to move her arms. As the arms move they seem
to multiply and then to begin tracing whirligig
gestures in the air. I ask the woman what she
thinks she's doing and she replies, 'Destroying
the glint of darkness.'

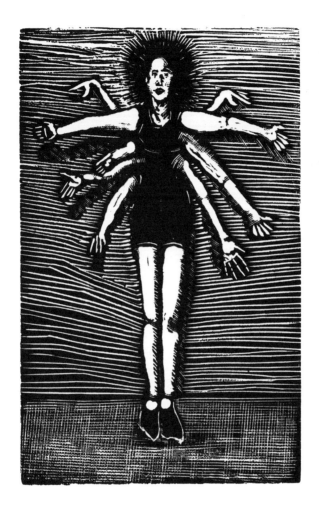

Timmy the Pierced Face Wonder — October 2003

Timmy's face was filled with straight and ring piercings. Large steel pins protruded from his mouth and nose. He told me his name was Timmy, though I had to ask him to repeat himself several times as I couldn't make out what he was saying through all the hardware in his mouth. I turn away and notice myself reflected in a mirror and am shocked to discover that my face is pierced too. When I turn back to face Timmy he looks me straight in the eye and asks, 'Ready?'

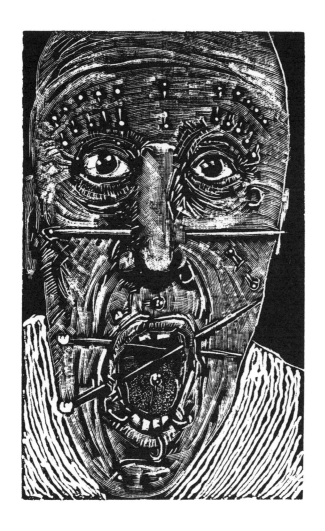

I find myself wandering around a circus where many of the performers display unique physical features. A melancholic dancer springs in front of me. She has four legs which she moves into graceful bras bas, plié, battement fondu and arabesques. She finishes her routine and climbs up the side of the canvas walls, disappearing into the darkness.

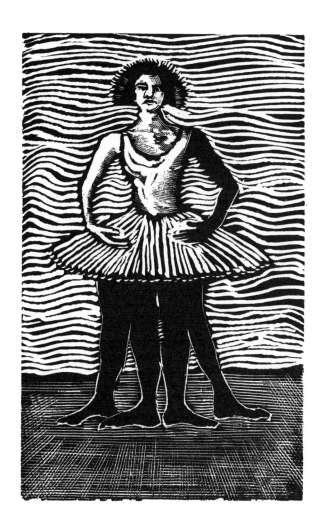

Whaler — March 2003

Projects I work on during the day often creep into
my dreams at night. I was reading a manuscript
about nineteenth-century whalers the evening
before I had this dream. I am on a boat with several
other whalers. We have harpoons and rope and gear
all piled up in the boat so it seems crowded. The
water is calm and everyone watches the surface
when suddenly the water heaves high and the boat
is thrown into the air. I fall into the water. As I sink
into the sea I see the whale descend into the depths
and at the same time I see the sailors on their boat
poised for the kill. The whale's dive pulls me deeper
into the water and I think that I may drown.

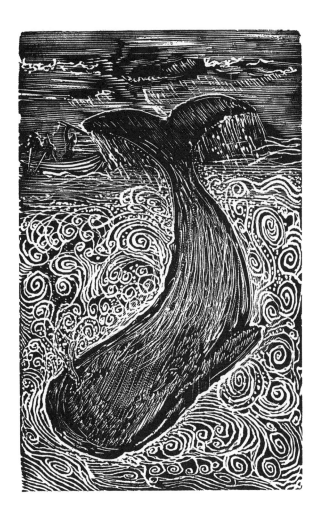

Skinhead — March 2003

This character approaches me from behind and
taps me on the shoulder. I turn and he says in a
Scottish burr, 'A puir man is fain o little.' My father
was once a featherweight boxer in Scotland. He
also had a shaved head and gold teeth. At first I
think this character may be my father but he
appears to be younger and seems to be lost.

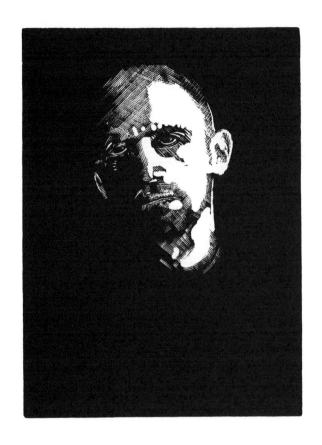

Birds of a Feather — March 2003

Looking up I see birds spinning in flight just over
my head. I can hear their wings beating and the
sound of their claws as they circle each other in an
entanglement of feathers and beaks. I am unsure
whether the birds are fighting or if they are furiously
trying to extricate themselves from their predicament.
The birds keep spinning as they rise higher and
faster until they become just a dot in the sky.

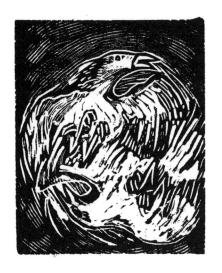

Dervorgilla's Dance — December 2001

I find myself in a room that has no walls, but
includes a beautiful woman dancing in the centre of
the floor. She is nude. As I approach she smiles
suggestively. We begin to dance and then to make
passionate love. At first the woman's face resembles
that of my wife, then as we continue to move she
dissolves into a mist that vanishes in my arms.

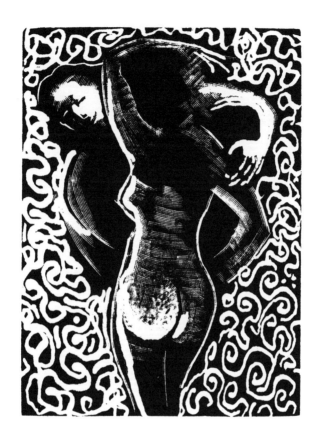

Turning in Sleep — December 2001

I often experience these sorts of jolts or convulsions
that occur just as I fall into sleep. This time I feel
my body lurch, but instead of waking I manage to
escape my mortal shell and find myself pressed
against the ceiling, looking down at my body
which lies motionless on the bed.

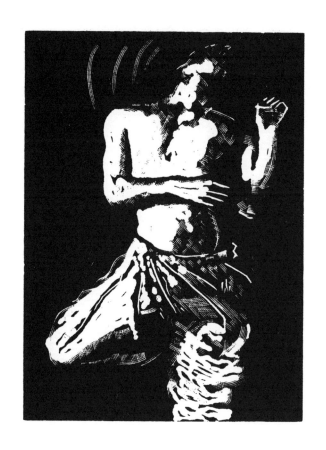

In Praise of a Lunar Phase — November 2001

A girl is dancing in the light of a full moon in the nude. The moon has a face that speaks to her. I can't hear what is being said but the dancer is very excited by the information the moon has to share.

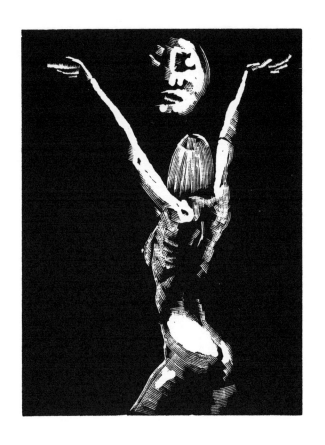

Father, Lunatic, Mask — November 2001

My father stands in the light of a full moon.
He has always been adversely affected by lunar
activity. My father curses and rages but the moon
retains its serenity, unaffected by my father's
trauma. In his anger he turns to confront me but in
place of his face I see a mask — neutral and
expressionless like the face in the moon.

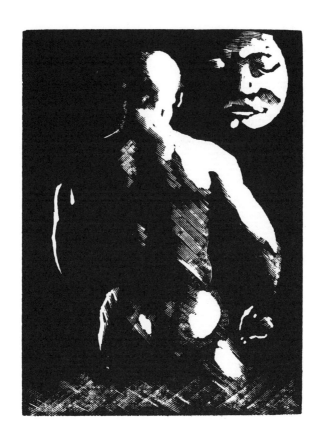

Animality — November 2001

I run down a path at night. I am nude and
searching for prey, as if I am more an animal than a
man. The moon in the night sky watches me
derisively as I race along a path that leads to
nowhere in particular, though I am searching, for
something, and the path twists and turns as I pass
through the night. I am hungry.

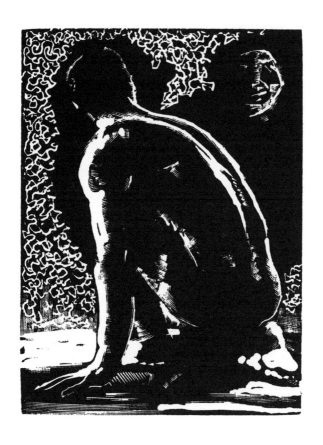

Buddha Sleep — October 2001

Like a statue of the Buddha I find myself sitting in a cross-legged position in an empty space frozen in time. I cannot move and I have no desire to move. My eyes are closed and yet I seem to be able to see clearly through the eyelids. After a time I raise my hands to my face to remove a bronze mask with the face of Buddha imprinted on it. The mask falls into my hands and I am jolted into consciousness.

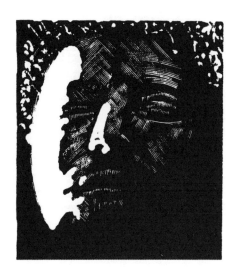

Dark Angel — 2001

I'd just finished reading Neil Gaiman's story
'Murder Mysteries' which I was planning to
illustrate for Biting Dog Press. I was haunted by
this story when I went to bed that night. The story
takes place in Heaven before Creation and before
the fall of Lucifer. In my dream I find myself on the
edge of a great darkness. Behind me is a towering
city that rises up, cutting through the darkness that
permeates everything else. Every stone surface of
the city gives off a luminous glow that feels warm to
the touch. Suddenly the darkness began to move
and a figure appears, shaking the darkness from its
body as if it had been covered in dust. The figure
stands for a moment, cascading light swirling
around it, before noticing me.

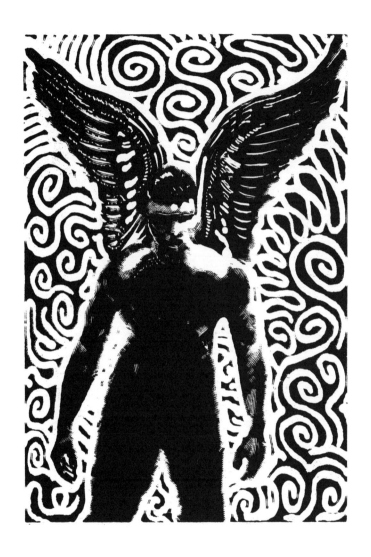

Spinning the Threads of Being — February 2001

What would an angel, grappling with the
Concept of Being, look like? When I'm
preoccupied with a graphic challenge like the one I
faced with the illustrations for Neil Gaiman's story
'Murder Mysteries', I often discover ideas for images
in my sleep. Here is a room filled with light and
winged beings spinning threads that are the strings
for the creation of more winged beings. In this
room the angels spin, sew and weave these winged
beings into existence.

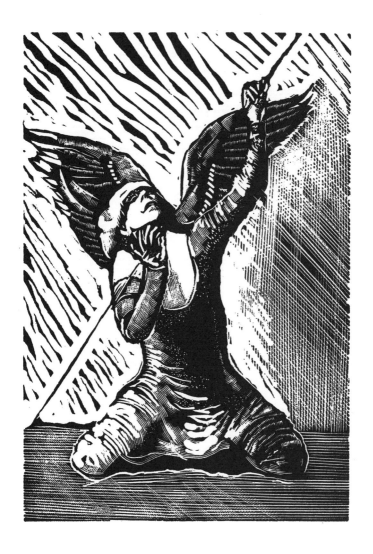

Eyes — February 2001

Eyes are often the key to the expression of emotions ranging from love to anger. We sometimes like to think of our eyes as windows into our thoughts, but all they really do is gather light. When disembodied eyes appear in my dreams, they frighten me. There wasn't a context or preamble that led to the appearance of these eyes, they just emerged — peering at me.

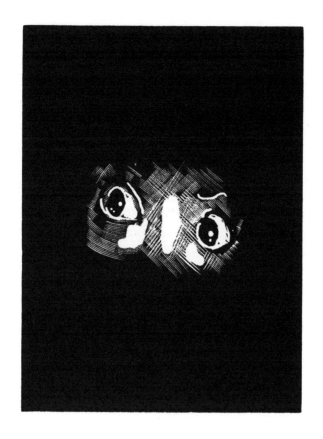

Archetype — February 2000

In many of my dreams it is easy for me to identify a
frame of reference to explain the reasons why I
dreamed the events or saw what I saw in a
particular dream. Sometimes it may have been a
movie I watched, a book I was reading or some
situation with family or friends that inspired the
dream. But every so often I have a dream that
doesn't seem to have any connection with my daily
experiences. In this dream I am standing with my
arms spread wide. I watch as my flesh becomes
transparent and I can see all the muscles and
organs. Then all of my flesh falls away and I am just
a skeleton but still alive and conscious.

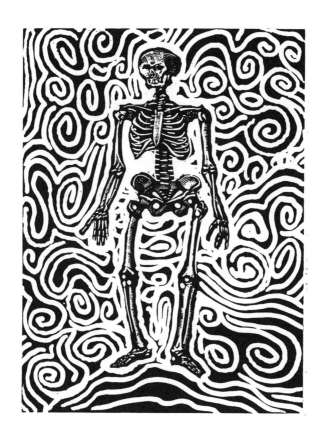

Transcendent Spin — February 2000

I look over the edge of a large hole that drops down toward a glowing light. As I'm looking down from the edge into the mouth of the hole I see various people falling into the hole's centre. Some of the people are familiar to me. Others, I don't know at all. The people all seem quite calm and collected as they jump in and fall toward the light. As I watch them fall, I come to the realization that many of these people are friends and family that have either passed away or are no longer a part of my life.

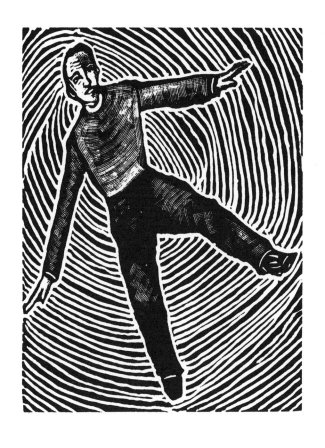

Constellate Mystique Flows In — February 2000

The face resembles that of a Maori warrior though
it has a cavity in its head. A hand reaches to pour a
liquid into the hole in the warrior's head. A voice
explains that the liquid is dreams and that the head
is trying to drink the dreams. I'm asked to help by
pouring more into the skull of the warrior.

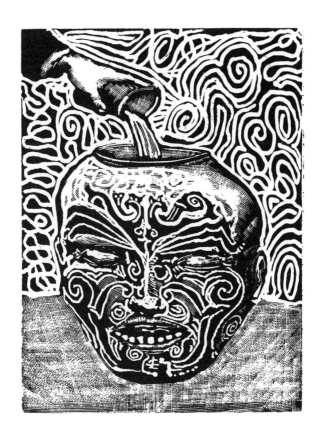

Here is a circus performer with two wolves who bark and balance on balls. The performer has an androgynous quality to his/her appearance. The performer announces that one of the dogs is male and the other is female, and that we should try to guess which is which as the show progresses. It's impossible to tell their sexes apart as the animals don't appear to be doing anything that would characterize the biological differences between them. I strain to see if I can identify the sex of the wolves by looking between their legs, but the crowd is large and pushing to get a closer view.

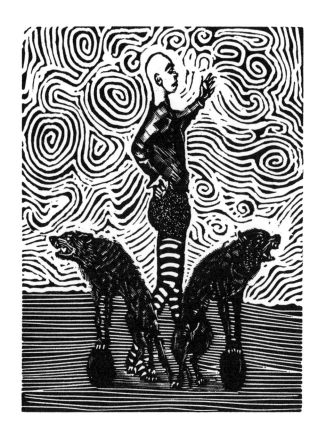

I had another archetypal out-of-body dream last night. This time my body was transparent as it floated away from me. I felt the same whole body convulsion that I have experienced on previous occasions, but this one was different in that my body became translucent and I felt as if I was in control of my journey. The experience of floating away led to a series of situations and events not unlike short plays. I have difficulty recalling the details of these little plays but I do remember feeling confident that I was in control of the situations.

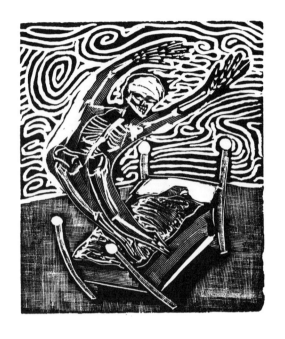

Flying Dream — May 1999

This time I have wings and the flying is effortless
as I move through the streets and alleys.
I'm aware that I am dreaming and the pillow
next to me displays flickering images as if it
were a video screen.

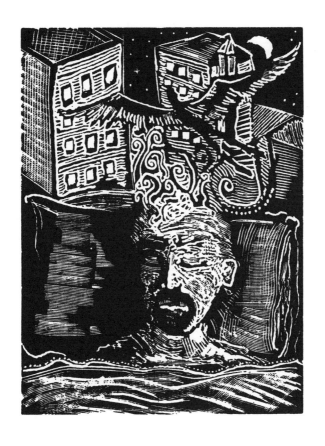

From the Building — January 1999

The street is empty, though I can hear a large
crowd of people talking somewhere just out of view.
The voices echo down the street. At first
it's just shadows that I can see moving but then
odd-looking creatures scuttle out of doorways
behind me. I turn to see something particularly
gruesome crawl from one of the doorways and into
the street. I start to run as fast as I can in the
opposite direction.

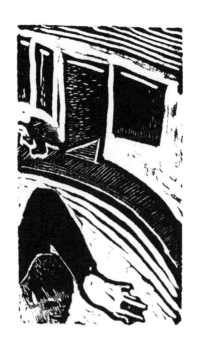

Seeing — April 1998

I'm walking along a familiar street when I meet up with a man whose face is all eyes. The man stops. Some of his eyes look at directly at me while others wander in every which direction as if the eyes are acting out a pantomime with some moral. Am I as aware of my immediate neighbourhood as I could be? Perhaps I should attempt to learn more about our neighbours on the street?

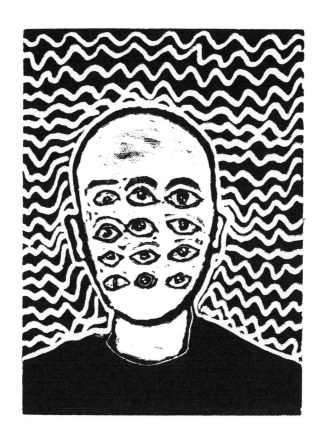

Sleepers Dreaming — 1998

The bed is positioned in the middle of an empty space under the moon and the morning star, Venus. It is unclear whether I am asleep, watching myself dream; or dreaming, watching myself sleep? I seem to spend a great deal of time in that twilight zone.

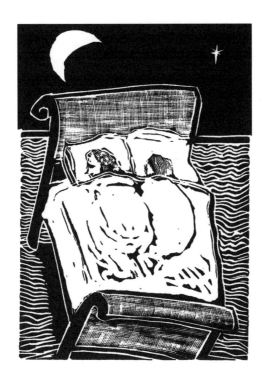

Hands on Fire — March 1997

I dream of a woman whose hands are on fire.
She does not seem to burn from the flames but
rather just plays with them as they flicker and
dance on her fingers.

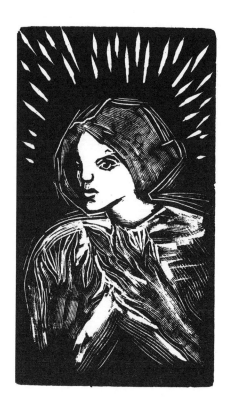

Two-headed Man — March 1997

I've often been of two minds when confronted by an
issue but this dream of two heads confused me
upon waking. I don't think it was a dream about
dual personality but more an illustration of my
ability to see two sides of a situation. In this case
there was a decision about a financial situation that
needed to be resolved. My wife and I had just
closed a store Michelle was operating and I was of
two minds as to whether we made the right choice
in cutting our losses or whether we should have
hung in a bit longer.

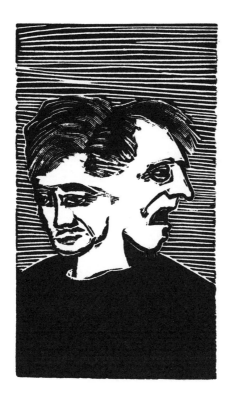

Cat-headed Accountant — March 1997

I dream of a cat-headed accountant. The accountant wears a suit and tie and is busily figuring numbers on a calculator when I appear before it to file my income tax. I can hear the accountant meowling as it rifles through papers. When the creature finally notices me I'm at a loss for words. I'm convinced this dream is triggered by the accounting service we use called CATS (Creative Accounting Tax Services).

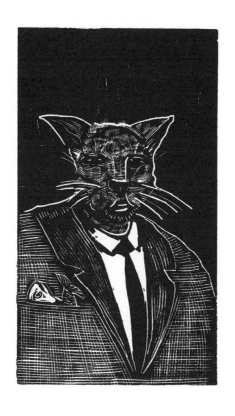

Free Fall — November 1993

I'm in free fall, spinning downwards towards a light.
An enormous crow circles above me as I fall.
I can feel my heart pounding in my chest. I think
the crow is after my heart, which is beating ever
louder in volume. My body turns, I hit the light
switch and my eyes open suddenly to find myself
staring at a bedroom lamp.

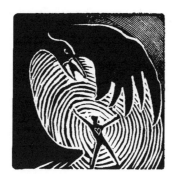

Drop of Water — August 1991

The forest is damp and misty and humid. It is strangely quiet except for a dripping sound that is echoing throughout the area. A single drop of water is falling into the lake from the sky. The sound is louder than one might expect. I dive into the cool water and swim down to the bottom. I feel an urgent need to breathe all of a sudden, and I struggle to reach for the surface. I wake with a gasp — to realize I have been holding my breath.

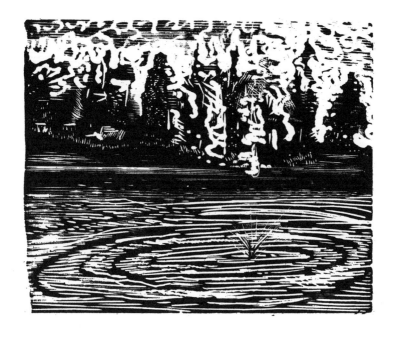

A Jungian Approach to Dreams and Dream Images

DARYL SHARP

According to research into the physiology of dreaming, we all dream, several times a night, shown by so-called REM phenomena — rapid eye movements. People deprived of the level of sleep at which dreams occur soon become anxious and irritable. Such experiments, while silent about the content or meaning of dreams, suggest that they have an important biological function.

The Swiss psychiatrist C. G. Jung went further: he believed that the purpose of dreams was to monitor and regulate the flow of energy in the psyche.

Dreams happen at night and most people think they have nothing to do with 'real' life. That's what I thought too until I woke up one morning with a dream that wouldn't go away.

My initial dream, the one that took me into analysis, was of a bouncing ball. I was on a street in the centre of a deserted city, surrounded by cavernous buildings. I was bouncing a ball between the buildings, from one side to another. It kept getting away from me, I could not pin it down. I woke up in a cold sweat, terrified, sobbing uncontrollably.

From this distance it seems quite innocuous. At the time it blew my whole world apart.

It was my introduction to the reality of the psyche, a kind of initiation, a baptism by fire. I did not know that something could be going on in me without my being aware of it. I believed that will power could accomplish anything. My credo was 'Where there's a will there's a way.' My dream came in the midst of a mighty conflict which I had a will to solve but no way. I kept thinking I could deal with it by myself. My reaction to the dream killed that illusion.

Daryl Sharp, B.Sc., B.J., M.A., Dipl. Analyt. Psych. is a graduate of the C. G. Jung Institute in Zurich. He has written many books on the practical application of Jungian psychology, and is the publisher of Inner City Books (www.innercitybooks.net) which publishes the series, Studies in Jungian Psychology by Jungian Analysts. He lives and practises in Toronto.

The psyche is the sum total of all psychic processes, conscious as well as unconscious. Psychic phenomena are in fact as real as anything in the physical world. The unconscious is quite independent of ego-consciousness; it not only reacts to consciousness and contains repressed contents that were once conscious, it is also the source for things that have never been conscious — it can create.

Jung describes dreams as fragments of involuntary psychic activity, just conscious enough to be reproducible in the waking state. They are self-portraits, symbolic statements of what is going on in the personality from the point of view of the unconscious.

Knowledge of oneself is a result of looking in two directions at once. In order to know ourselves we need both relationships with other people and the mirror of the unconscious. Dreams provide the latter mirror.

Dreams are independent, spontaneous manifestations of the unconscious. Their message seldom coincides with the tendencies of the conscious mind. They not only fail to obey our will, but often stand in flagrant opposition to our conscious perceptions and intentions. They are not more important than what goes on during the day, but they are helpful comments on our outer existence and attitudes.

Freud's view was that dreams have an essentially wish-fulfilling and sleep-preserving function. Jung acknowledged this to be true in some cases but focused on the prominent role dreams play in the self-regulation of the psyche. He suggested that their main function was to compensate conscious attitudes — to call attention to different points of view, and in so doing to produce an adjustment in the ego-personality.

Compensation is a process aimed at establishing or maintaining balance in the psyche. If the conscious attitude is too one-sided, the dream takes the opposite tack; if the conscious attitude is more or less appropriate, the dream seems satisfied with pointing out minor variations; and if the conscious attitude is entirely adequate, then the dream may even coincide with and support it.

Dreams have a compensatory function in that they reveal aspects of the personality that are not normally conscious; they disclose unconscious motivations operating in relationships and they present new points of view in conflict situations.

Jung also emphasized the prospective function of dreams, which means that in many cases their symbolic content outlines the solution of a conscious conflict. This is in line with his view of neurosis as purposeful: the aim of dreams is to present to consciousness the information needed to restore the psyche to health.

If that is so, why are dreams so darned hard to understand? Jung's enigmatic answer is that 'the dream is a natural occurrence, and nature shows no inclination to offer her fruits gratis or according to human expectations.'

Indeed, it takes hard work to understand dreams. We aren't used to their symbolic language. The combination of ideas in dreams is essentially fantastic and irrational; images are linked together in a way that as a rule is quite foreign to our usual linear way of thinking. At first sight they often make very little sense. And at second sight too. The language of dreams certainly takes some getting used to.

One of my dreams after I started analysis in Zurich was of a spider on skis, on a razor blade. Now I ask you. And people say the unconscious has no sense of humour.

According to Jung, a dream is an interior drama. The dreamer is the stage, the scene, the director, the author, the actors, the audience and the critic. The dream is the dreamer. Each element in a dream refers to an aspect of the dreamer's own personality; in particular, the people in dreams are personifications of complexes — inner personalities with a will of their own.

Dreams confront us with our complexes and show them at work in determining our attitudes, which are in turn responsible for much of our behaviour. The work required to understand the message of a dream, or a series of dreams, is one of the best ways to depotentiate the complexes because through this focused attention we establish a conscious relationship to them. Our own dreams are particularly difficult to understand because our blind spots — our complexes — always get in the way to some extent. Even Jung, after working on thousands of dreams over a period of fifty years, confessed to this frustration.

Freud was the first to suggest that it is not possible to interpret a dream without the cooperation of the dreamer. You need a thorough knowledge of the outer situation and the conscious attitude at the

time of the dream. This, and personal associations to the images in the dream, can only come from the dreamer. If the essential purpose of a dream is to compensate conscious attitudes, you have to know what these are or the dream will forever remain a mystery.

The exception to this is archetypal dreams. These are distinguished by their impersonal nature and the presence of symbolic images and motifs common to myths and religions all over the world. They commonly appear at times of great emotional crisis, when one is experiencing a situation that involves a more or less universal human problem. They tend to occur in transitional periods of life, when a change in the conscious attitude is imperative.

There is no fixed meaning to symbols or motifs in dreams, no valid interpretation that is independent of the psychology and life situation of the dreamer. Thus the routine recipes and stereotyped 'definitions' found in traditional dream books are of no value whatever. Such books may be fun to read but are no help to the serious student of dreams. There is no convincing evidence that we can control our dreams — consciously manipulate their content; nor would it be desirable even if we could, for one would thereby lose valuable information that is not available otherwise.

Many dreams have a classic dramatic structure. There is an exposition (place, time and characters), which shows the initial situation of the dreamer. In the second phase there is a development in the plot (action takes place). The third phase brings the culmination or climax (a decisive event occurs). The final phase is the lysis, the result or solution of the action in the dream. It is often helpful to look at the lysis as showing where the dreamer's energy wants to go. Where there is no lysis, no solution is in sight.

The best way to profit from the information in one's dreams is through a dialogue with another person, preferably someone trained to look at dreams objectively and not likely to project his or her own psychology onto them. Even an analytic knowledge of one's own complexes is no guarantee against projection, but without training of some kind both parties are in the soup.

The first step is to determine the personal associations to all the images in the dream. If there is a tree, say, or a rug or a snake or apple, it is important to know what these mean in the experience of

the dreamer. This takes the form of circumambulating the image, which means staying close to it: 'What does a snake mean to you?' … 'What else?' … 'And what else?' This is not the same as the traditional Freudian method of free association, which eventually gets to the complex but may miss the significance of the image.

On top of personal associations to dream images there are often relevant amplifications — what trees or rugs or snakes or apples, for instance, have meant to other people in other cultures at other times.

These are called archetypal associations; they serve to broaden conscious awareness by bringing in material that is not personally known but is present in the collective unconscious as part of everyone's psychic heritage. The same images and motifs that turn up in dreams are the substance of myths, religions and fairy tales. Hence a working knowledge of these is an integral part of an analyst's training.

Garnering personal and archetypal associations to a dream — examining its context — is a relatively simple, almost mechanical, procedure. It is necessary but only preparation for the real work, the actual interpretation of the dream and what it is saying about the dreamer's life and conscious attitudes. This is an exacting task and an intimate experience for those working on it together.

Dreams may be interpreted on a subjective or an objective level. The former approach considers a dream strictly in terms of the dreamer's own psychology. If a person I know appears in my dream, the focus is not on that actual person but on him or her as an image or symbol of projected unconscious contents. Where I have a vital connection with that person, however, an objective interpretation may be more to the point — the dream is saying something about our relationship.

In either case, the image of the other person derives from my own psychology. But which approach is more valid has to be determined from the context of the dream and the personal associations. That is why there is no valid interpretation of a dream without dialogue, and why the dreamer must have the final say. What 'clicks' for the dreamer is the 'right' interpretation — for the moment, because subsequent events, and later dreams, often throw new light on previous dreams …

What are we to make, then, of my bouncing ball dream?

In the first place, it is typical of the kind of archetypal dream one has in a midlife crisis, when a change in conscious attitudes is imperative. Personal associations are not crucial because their meaning is more or less transparent. With a minimal knowledge of archetypal motifs, they reveal the psychology of the dreamer at the time of the dream, whether one knows the dreamer's outer circumstances or not.

My centre (the ball as an image of my wholeness) is pictured as being in a city, a collective space. The difficulty is clearly one of keeping the opposites in balance. A ball, compared to anything else that naturally occurs in nature, contains the largest internal volume for a given surface area. It cannot contain more without splitting the surface — or the surface must expand in order to contain more. It is a thus a symbol for both self-containment and the self-regulating process in the psyche. The ball — my wholeness — keeps getting away from me. The compensating message of the dream is that I am not in control. Perhaps, if I could establish a personal centre, if I could become more contained....

Other than in a professional analytic dialogue, a good way to understand one's dreams is by working with their images in a creative way, for instance by drawing, painting, sculpting or dancing them. This approach too was pioneered by Carl Jung. He called it active imagination. It is the course undertaken by George A. Walker, as described and illustrated in this volume of engravings that are redolent of archetypal themes that have shaped his life inside and out.

Walker's images come raw from the unconscious. It is his heart and his skill as an artist that brings them to life for him and for us.

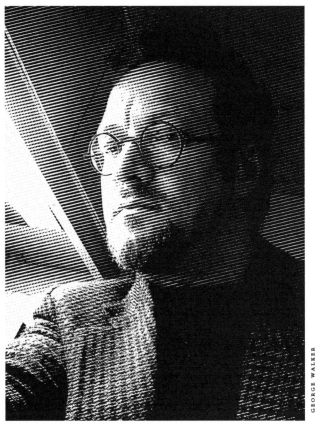

George A. Walker is an award-winning wood engraver, book artist, designer, teacher, author and illustrator who has been creating artwork and artist's books and publishing with a variety of both private and commercial imprints since 1984. Walker's popular courses in book arts and printmaking at the Ontario College of Art and Design (OCAD) in Toronto, where he is Associate Professor, have been offered continuously since 1985. For over twenty years Walker has exhibited his wood engravings and limited edition productions internationally, often in collaboration with his colleagues at The Loving Society of Letterpress (and The Binders of Infinite Love) and with the Canadian Bookbinders and Book Artists Guild (CBBAG, pronounced 'cabbage'). Among many book projects of particular note Walker has illustrated two hand-printed books written by the popular American novelist Neil Gaiman. Walker also illustrated the first Canadian editions of Lewis Carroll's *Alice in Wonderland* and *Alice Through the Looking-Glass* for Cheshire Cat Press. George Walker was elected to the Royal Canadian Academy of Art (RCA) in 2002 for his contribution to the cultural area of Book Arts. The Porcupine's Quill published Walker's earlier collection *The Inverted Line* in 2000.